The Resilient Cultural Organisation

The Resilient Cultural Organisation

Peter Latchford

CONTENTS

Introduction ...7

How to Use This Book...9

1 The Balanced Culture Organisation.....................................13

2 The Flexible Culture Organisation26

3 The Strategic Culture Organisation....................................35

4 Reviewing the Customer Journey61

5 Change Management..64

6 Programming Best Practice..79

7 Finance and the Culture Organisation...............................95

Conclusion...111

INTRODUCTION

These are tough times for cultural organisations. The financial crisis landed a double blow on the sector. It simultaneously reduced the audiences' disposable income, while requiring that governments (national and local) drive down any non-essential spending.

We could have a philosophical debate about whether culture is essential – and many have – but it would not (it did not) change the reality we are experiencing: an increase in cost-conscious consumers and big reductions in public subsidy.

The best organisations have rallied. Some have gone to the wall. Almost all have been forced to retrench.

A number took the opportunity to rethink what they are and what they offer; to tighten the way they operate; to sharpen their act. They looked at how they could increase the revenue streams they received from their audiences and from funders, other than the traditional public purse.

We have worked with some of the best of these. This book distils the insights learned on the way. At the heart of the approach is a simple analysis of good enterprise components.

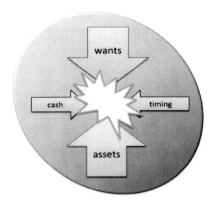

Good culture sector enterprise happens when something that one person has (their **asset**) aligns with something the other person desires (their **want**). For this to happen – in addition to there being a genuine alignment – there usually has to be good information flow, some spending, and the right timing. Of these, the information flow is the most challenging. An asset owner will tend to describe their asset in asset-related terms (the artefact, the play, the gallery). The potential customer will tend to perceive their want in ego-specific ways ("to be entertained", "to get out of the house", "to impress my children"). Unless this vocabulary gap is bridged, there is no enterprise.

> *The biggest enterprise challenge of all is to get an asset-owner to see that asset through the lens of a potential customer.*

Black Radley has been a public service troubleshooting consultancy for 15 years. We have a particular interest in enterprise, governance, and the relationship between the two. For the last five years, we have been working with cultural organisations, particularly those in, emerging from, or closely tied to the public sector.

HOW TO USE THIS BOOK

An effective culture organisation must be like a martial arts master practitioner. It must have clarity of purpose, flexibility of approach, and a strong sense of balance. If it has these things, it has *resilience*.

Section 1 takes these themes – **balanced, flexible, strategic** – and looks at what they mean in practice in the cultural sector, and how an individual organisation can assess where it stands.

Section 2 looks at how a culture organisation, having identified where it needs to improve its resilience, can start to change.

Section 3 sets out simple best practice around the central issue of shows and programming.

Section 4 examines a culture organisation's basic financial model – how finances work, or should work, in this setting.

The text is kept uncluttered and the theory limited. This is a book for pragmatists and practitioners; for leaders and the enlightened; for those who see enterprise as being part of culture, rather than its enemy.

SECTION 1

The Meaning of Resilience

1 The Balanced Culture Organisation

All life is balance; a balance between duty and pleasure, work and play, sweet and savoury.

Organisations experience multiple tensions. At the macro level, all organisations must balance customer satisfaction with stakeholder interests. In culture organisations, this customer/stakeholder tension plays out with different emphasis: for private sector players, it is customer satisfaction vs shareholder return; for public sector players, it may be public vs politician; for not-for-profit players, it may be audience vs funder.

This tension can produce ambiguity and stress for front-line staff, senior management, and boards.

A theatre director complains that box office pressures force her into populist programming, at the expense of the experimental theatre she loves.

A museum curator resents being told to prioritise after-hours tours for wealthy but philistine customers.

A public gallery manager struggles to reconcile his professional reputation with elected member enthusiasm for a Jack Vettriano exhibition.

The balance between customer care and contractual obligations cannot be "designed-out" by policymaker science, nor managed away by management hierarchies. The creative tension between the people and numbers perspectives can and should drive continuous improvement. The tension between these dimensions is specific to each decision made at every level throughout the cultural economy. It relies on the sense, conscience, and *enterprise* of everyone who works in that economy.

It is not unusual for culture sector people to complain at the commercialism being forced upon them. The truth is that commercial revenues have always been an important part of the financial model. What we are seeing is a slight shift in emphasis, driven by reductions in public spending.

In our experience, those who complain loudest about the negative impact of commercial revenue are often those who have used public subsidy to pursue their own narrow interests, at the expense of wider participation and enjoyment.

Organisational Fitness

Culture managers must explicitly recognise the people/ numbers tension. It is not a choice ("people **or** numbers"): it is a balance ("people **and** numbers") in which, ideally, a numbers perspective supports the provision of brilliant cultural offerings.

An organisation's management team has a major influence on the internal climate, on the belief system. In particular, the organisation's culture is shaped by the way performance is judged – by the measures, issues, and vocabulary employed in recognising and rewarding individual success. If what managers say is important does not match with what they reward, there will be problems. Effective culture organisation management explicitly recognises, and finds ways of rewarding, a balance between the artistic and the commercial, between the ethos and the cash flow.

One very successful director of a producing theatre sees no inconsistency between the cultural and commercial imperatives. He speaks of the issue as simply one of phasing. "If I am lucky, today's avant garde production will be tomorrow's cash cow – my job is to educate and build the audience. I must do this, because today's cash cow will be old hat tomorrow."

This tension between people and numbers is just the headline issue. In practice, culture organisations must navigate a number of creative tensions that underpin this top level. These are best represented as a three-cornered balance. In each case, decision-makers must maintain a responsive balance between three competing priorities or perspectives.

This section sets out the core set of three-cornered balances fundamental to culture organisation performance.

Vitality Dimensions

Culture organisations are, like all organisations, three things at once.

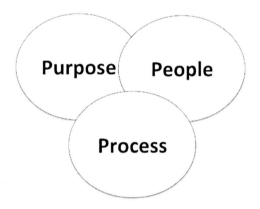

They are purposive (there to achieve a **purpose** and a set of clear performance indicators);

They are communities (comprising brilliant, flawed, interconnected **people**, staff, stakeholders, and individuals);

They are machines (a set of activities and **processes**, running more or less smoothly).

Effective performance results from decision-makers maintaining all three perspectives at once, and the right balance of attention between them. Typically, culture organisations are imbalanced in their attention to these three.

It is not unusual, for instance, for cultural organisations to be very concerned about their staff happiness at the expense of solid processes and dependable performance. In this case, the management challenge is not to treat their people less well – but to increase their emphasis on clarifying/bedding in good practice (process), and on holding people to account for helping the organisation achieve what it is there to achieve.

> *"I cannot build an exhibition around our 19th century art collection," the gallery director told me. "My curator is concerned about the damage the public might do if the work is displayed."*

Purpose Balance
Under the Purpose dimension, there is a further three-cornered balance to be achieved.

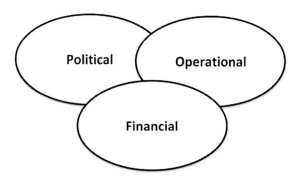

The organisation must perform **operationally** – which means providing excellent service and hitting its contractual targets.

The organisation must perform **politically** – which means keeping a range of individual stakeholders happy and on side.

The organisation must perform **financially** – which means being efficient, avoiding overspend, and maintaining long-term viability.

If any one of these aspects of purpose is allowed to dominate, problems will arise under the other headings. An imbalance between the financial and operational aspects, for instance, can lead to severe budget problems or, conversely, to operational performance failings.

"The show was a triumph!" the director said. "Unfortunately, our backers dropped out and the audience did not come in sufficient numbers. The theatre was forced to close."

It is not unusual for culture sector managers to see the financial dimension of this balance as being grubby or sordid when set against the cultural product produced. In practice, the best results (financial and cultural) are achieved by those organisations that see the finance dimension as one of the crucial parameters that help frame and enliven their creativity.

"We expect our exhibition programme as a whole to make a positive financial contribution and to stretch people," a museum director told me. "But the financial model for each exhibition will vary. Some will be shamelessly populist – aimed at generating footfall. Usually, these will be free entry. They are about building the museum visiting habit – and about justifying the Council's subsidy. Other exhibitions will be for a

much narrower market, will typically be ticketed, and help us keep our credibility with national cultural funders."

People Balance

Under the People dimension, there is a further three-cornered balance to be achieved.

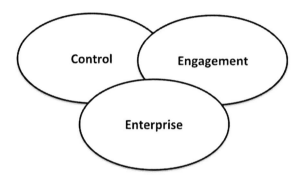

The people working within the organisation must work under appropriate **control**: cooperatively, in a coordinated and quality-assured fashion, following established frameworks and good practice.

This means:

- Continually reflecting on what works and does not work – utilising an action/review/adjust cycle;
- Designing, following and refining effective processes;
- Using appropriate levels of performance information.

People must be encouraged to be **enterprising**. This includes:

- A risk management approach that encourages appropriate levels of responsibility and devolved decision-making – creating an environment in which people feel safe to take risks;
- A culture of customer responsiveness;
- An emphasis on teamwork; proactively encouraging links between functions and specialisms.

Management practice must place a premium on **engagement**; on staff developing and working with and through links with others (with colleagues, individuals, and partners). This includes:

- A focus on the importance of interpersonal skills and emotional intelligence;
- Permeability (at the individual and organisational level) to "informal information" (anecdote, feedback, intuition, observation, management by walking about);
- Creating opportunities for internal, lateral, and external relationship development.

"As far as I am concerned," the Council cabinet member for culture said to me, "you get quality through control, tight control. I write the spec, and the staff deliver it. The closer their delivery is to the spec, the better the quality of the product." By all objective and subjective measures, the performance, impact and value of his service was well below average.

Process Balance

Finally, under the Process dimension, there is a further three-cornered balance to be achieved.

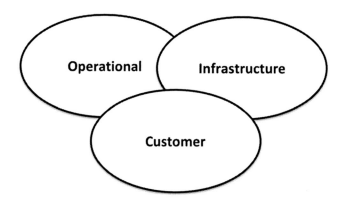

The organisation must have a clear approach to defining, implementing, and reviewing its core **operational** implementation processes.

The organisation must have a clear approach to defining, implementing, and reviewing its core **customer** management processes.

The organisation must have a clear approach to defining, implementing, and reviewing its core **infrastructure** processes, from maintenance to financial prioritisation.

Often, culture organisations place considerable emphasis on the "episodic" aspect of their operational processes: they have an established way of bringing a show, exhibition or event to completion. But they neglect the ongoing parts of

their operational machinery. And they give insufficient time to maintaining and developing the fabric of the organisation and the processes that entice and enthuse the customer.

"We are a great team," she said. *"Every time we put on a show, we fight our way through the inevitable series of crises, and somehow muddle through. Last month, for instance, the whole team, including the cast, voluntarily manned the phones when our ancient booking system finally gave up the ghost."*

Balanced Performance Framework
These four three-cornered balances make up a straightforward performance model. This framework is the basis of the **Balanced Performance Model (BPM)**.

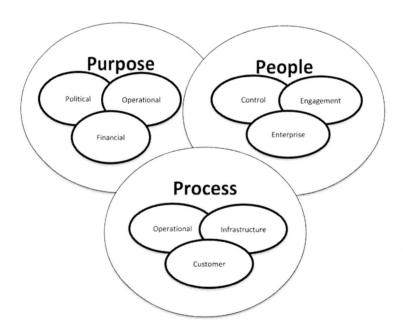

Getting Fit

The Balanced Performance Model is simply a way of looking at the world. It recognises, and tries to correct, every manager's tendency to favour one perspective over another; to see the world through the prism of his or her favoured management style.

"If you only have a hammer, every problem looks like a nail."

Good management results from two things. It comes from having: (1) a wide range of management tools in the toolbox; and (2) the ability to know which one to use. The Balanced Performance Model supports this second requirement, by helping the culture organisation manager broaden his or her diagnostic ability. These concepts can be employed regularly at all management levels to ensure a balanced focus.

Deeper Dive Analysis - Focus Points

The model can also be used to underpin a one-off exercise: a deeper dive consultancy study, or diagnostic exercise; giving a picture of a culture organisation's balanced performance and how improvement can be achieved. The organisation determines, using its own or external resources, where there is imbalance: where a perspective or dimension is problematic, undervalued, or simply ignored.

This deeper dive focuses on key points of interplay between the three-cornered balances described. A diagnostic process is applied to seven focus points:

Purpose/Process/People: Focus Point 1
Purpose 3CB: Focus Point 2: Purpose/People
 Focus Point 3: Purpose/Process
People 3CB: Focus Point 4: People/Purpose
 Focus Point 5: People/Process
Process 3CB: Focus Point 6: Process/Purpose
 Focus Point 7: Process/People

Focus Point 1: Purpose/Process/People
At the top level, strong organisational performance comes from achieving the right balance between a purpose perspective (*we are here to get the job done*); a people perspective (*we care about the people who work and are served here*); and a process perspective (*we must follow best practice*).

Focus Point 2: Purpose/People
The organisation asks itself whether it has in place the right staff controls, the appropriate stakeholder relationships, and a sufficiently enterprising culture to deliver its fundamental purpose.

Focus Point 3: Purpose/Process
The organisation looks at the extent to which it has in place the right delivery processes, customer management processes, and administrative or support processes to deliver its fundamental purpose.

Focus Point 4: People/Purpose

For humans to work effectively as a team, they need the right management information and clarity of purpose. They need that clarity in operational, political, and financial terms. The organisation looks at the extent to which they have this.

Focus Point 5: People/Process

For humans to work effectively as a team, they need clearly defined processes. These processes should set out how the core delivery functions should work, how customers/ stakeholders should be supported, and how administrative/ support activities should run. The organisation considers the extent to which these simple processes are in place and followed.

Focus Point 6: Process/Purpose

An organisation can only have clearly defined and implemented core processes if it knows what it is trying to achieve. It looks at the extent to which it has in place the right management information and clarity of purpose (political, operational, financial) to give proper focus and simplicity to its basic core processes.

Focus Point 7: Process/People

An organisation's core processes will only work properly if the right controls are in place to make sure people follow those processes. But they will also only work if those processes give sufficient flexibility to staff that they are able to be enterprising within agreed parameters; and if they feel there is a two-way dialogue with management.

2 The Flexible Culture Organisation

Our bodies need to be both fit and flexible, if we are to be fully healthy. A cultural organisation needs to be balanced (fit); the subject of the last section. In response to unpredictable times and the need for commercial revenue, it also needs to be enterprising (flexible).

Good cultural enterprise results from the effective management and interplay of three themes.

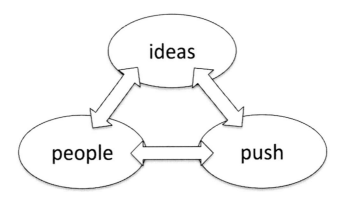

There must be a continual flow of new **ideas**, new initiatives, and new ways of doing things, into and through the organisation.

The right **people** must be in place, with the right attitudes, skills, and teamwork to turn the ideas into reality.

The organisational context must provide the right **push** to ensure the right ideas are made real.

For each of these themes to be strong, an organisation needs to create the right **context**, it needs to develop the appropriate understanding or **knowledge**, and it needs to manifest the right **behaviours**.

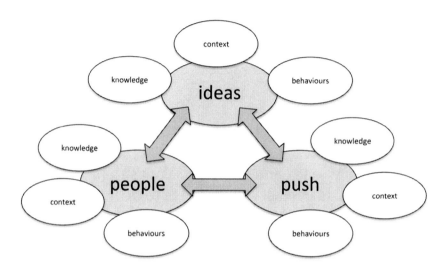

The gallery, once the pride of the city, had lost its way. There were damp patches on the ceilings of the exhibition rooms, the permanent exhibits had not been refreshed for some considerable time, and no major touring shows were booked. The Friends group was obstructive, the Council subsidy was being halved, and the gallery appeared to have little relevance to the diverse community now living in the city. The staff had very clear ideas about why change was not possible, or even desirable.

The theatre company started with nothing. The founder, an out of work actor, persuaded a number of his peers to put on a play. It lost money. They tried again, and found that young people responded to their work positively. They discovered they could just about survive putting on shows for children. They honed

their skills, occasionally experimenting with new, more adult, productions in halls and other generic spaces. Eventually, one of these shows achieved national critical acclaim, leading to a mainstream theatre booking. New contacts were made: as a result, a writer created a new play for the company, which was highly successful. The company's growing profile generated increased touring revenues and the opportunity to move into their own dedicated theatre space.

Creating the Enterprising Context

For flexibility and enterprise to flourish in a culture organisation, its internal culture needs to be right. In simple terms, this means that its internal feel – its habits, feel, ways of thinking and doing – must encourage enterprising practice. This is "context". There are three context domains under each of the three main themes of ideas, people and push.

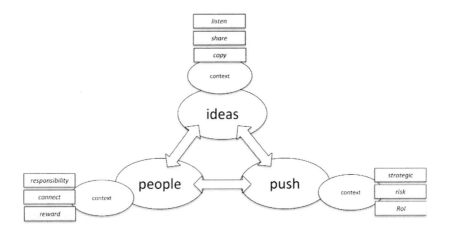

As far as ideas go, do we **listen**? Are there effective processes in place for listening to the wants of customers and other

stakeholders? Do we **share**? Are there effective processes in place for sharing ideas, successes, and failures with other culture organisations? Do we shamelessly **copy**? Are there effective processes in place for borrowing and learning from other organisations' practice?

Good listening is the most simple and the most difficult activity. At its most basic, it happens when staff (all staff, at all levels, especially the most senior) are encouraged to ask audiences/visitors, "What did you like? What did you not like?" It is about establishing an online presence that encourages the sharing of information and views. It is about mystery shopper exercises, feedback forms, email experiments, competitions that generate engagement... it is about the organisation being brave enough to hear what it does not want to hear.

When it comes to people, do we delegate **responsibility**? Does the organisation have a culture that allows effective people to get on and make their project work? Do we **connect**? Does the organisation stimulate and encourage soft links between specialisms within the culture organisation and with external partners? Do we **reward**? Does the organisation encourage people (even if only through gratitude) for driving new ideas forward?

*Culture organisation managers are often reluctant to empower their people. It can feel irresponsible; an abrogation of what the manager is there to do. It can feel extremely risky, since most managers are all too acutely aware of the shortcomings of the people in their team. It can feel threatening; an undermining of authority. It **is** risky. Most organisations will have some staff that are not capable of being treated like adults. But the risk of not delegating is more risky, since, in a fast-changing*

environment, responsiveness needs to be built into the front line. The trick is to establish, and tightly control a compelling, artistic direction and a clear set of values.

Then there is the organisation's drive, or push. Are we **strategic**? Is the organisation focused and clear about its proposition and target markets? Do we have the right attitude to **risk**? Does the organisation have effective risk management processes? Does the organisation have a **Return on Investment** philosophy? Does the organisation use such a perspective as a key part of all management decision-making?

Museums plan their exhibition programmes five years in advance. Enormous resources and management effort go into this aspect of their work. But rarely do museum management teams calculate what financial return this investment should make them.

Encouraging Enterprising Behaviours

A strong culture organisation does what it does in an enterprising fashion. Its day-to-day activities, the processes it defines and implements, the work on which its time is spent – these all support and enable flexibility and innovation. There are three

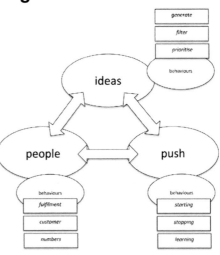

behaviour domains under each of the three main themes of ideas, people, and push.

For ideas, do we **generate** good, new ideas from all sources? Does the organisation **filter** these ideas, assessing robustly which ones to go with? Are we able to **prioritise** ideas on the basis of financial, political and operational considerations?

Customers can be great ideas generators, though the kernel of the thought may need to be stripped of its unrealistic specifics. Staff – who see what interests people every day – can be boiling with good ideas, if only they are listened to. Managers often block out new ideas because they don't have the capacity to think about them. A simple, agreed prioritisation framework, allowing people to say "no" to things, can be the single most powerful means of getting managers to listen more.

From a people perspective, do we **fulfil** – is the organisation good at making things happen in line with plans? Are we good at working with **customers** and understanding their perspectives? Are we good at estimating, forecasting, and modelling **numbers**?

Some shows generate significantly more secondary spend (shop and catering sales) than others. Unless we track these patterns, how can we make decisions about future shows and their likely financial performance?

From a management drive or push perspective, are we good at **starting** things? Is the organisation able to initiate and progress new ideas/initiatives/projects? Are we good at **stopping** things? Is the organisation able to review, prioritise, and shut down ideas/initiatives/projects? Are we good at

learning from this? Are we able to learn from successful and unsuccessful ideas/initiatives/projects?

Good culture managers know that prioritising is not about saying what's important – that's easy. It's about saying what we will stop doing. What will you stop your organisation doing tomorrow?

Knowing What We Need to Know

A successful, flexible culture organisation keeps track of its changing world; it knows what it needs to know and constantly asks questions.

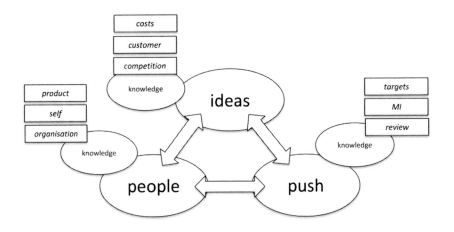

From an ideas perspective, do we know about **costs**? More specifically, does the organisation know how to construct a credible financial case? Are we clear who our core **customers** are? Do we know how to identify relevant target markets? Is the organisation clear on its **competitors**? On what

alternative uses the potential customer might have for their spend?

Many museums, when asked who their audiences are, will say something that can be translated as meaning "everybody". This is not possible. It results in a grey, flat offer. Good museums know who their primary customer groups are, and how the offer relates to the interests and characteristics of those groups.

As far as our people are concerned, does the organisation know who has the best knowledge and experience relating to a specific **product**, idea or initiative? For the organisation as a whole, and in relation to a specific project or initiative, how good is our knowledge of **self** – do we know our strengths and weaknesses, technical and attitudinal? For any given project or development, does the team assigned have the necessary credibility and passion to steer the idea/initiative through this **organisation**?

In the performance world, a good performer must have sensitivity – to her audience and to her fellow players. It is therefore necessary that the performer is protected from input that may be damaging. But this can mean that the organisation becomes esoteric and insular, refusing to listen to feedback. Good management establishes a culture of artistic and personal resilience, whilst actively seeking out and distilling feedback with commercial relevance.

From a management push perspective, have we defined the hard **targets** for what the organisation or the project should achieve? Do we know the clear, regular, timely and simple **management information** that we will use to track progress against the target? Do we know how we will **review**

progress on a regular basis, identifying learning points and priority areas for attention?

In response to a cut in core funding, a museum director gave every member of staff an income generation target. As a consequence, disagreements broke out across the organisation, as different departments sought credit for the limited set of small revenue items over which they could claim some influence (room bookings, donations). The major revenue streams, for which effective cross-functional working was required, suffered as a consequence.

2.1 Enterprise Engine Framework

Taken together, these themes, headings, and domains create an **Enterprise Engine Framework**; a comprehensive checklist for managers that allows them to identify and track organisational responsiveness.

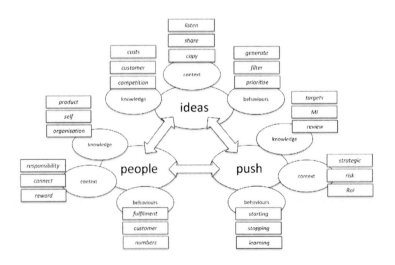

3 The Strategic Culture Organisation

The preceding sections drew the analogy between a fit, flexible body and a balanced, enterprising organisation. In neither case will much be achieved unless there is also focus. To get things done, a person needs to be purposeful. To achieve success, an organisation needs to be strategic.

Many culture organisations talk the language of strategy. They have visions, mission statements, objectives, and shelves full of plans. But these are often simply window dressing. Too often, we see culture organisations trying to be all things to all people – using the vocabulary of inclusion to mask an imprecision in management thinking. No organisation succeeds if it does not know what value it adds and to whom.

Strategic Sequence

The strategy process is messy. At its heart, it should be an on-going revise-and-review cycle, asking these three key questions over and over:

- Where are we now?
- Where should we go?
- How do we get there?

It is messy because the answer to one question often changes the way the other questions need to be framed.

We can simplify. And we can do so in a way that goes to the heart of a culture organisation's functions.

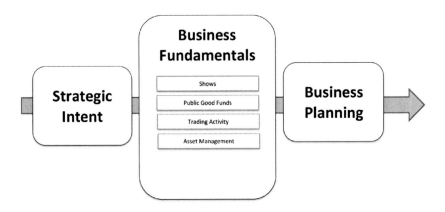

First, an organisation should clarify its "strategic intent": we should ask ourselves, what is our value-adding proposition? Second, we should review our four key functions in the light of that proposition. And finally, we should turn that review into a plan, with a financial model that works. If it does not, we should go back and change our proposition and work it through until it does.

Strategic Intent

There is a lot of fluff written about strategy; about vision and mission statements; and about strategic planning. The plain truth is that, unless the organisation has fundamental clarity of purpose, the rest of the paraphernalia of strategy adds little value. To achieve clarity of purpose is to set out your strategic intent.

There are four simple components.

- **Vision**
 This is a compelling picture of what you would like the world to be like; that is, the world in which you operate. It is bigger than your organisation: it is not a compelling picture of your organisation. The point is not just to have any old vision; it is to settle on an inspirational description of a brave new world, capable of inspiring and enthusing the key people.

"We see a world in which people's lives are energised and transformed by the power of live performance."

- **Mission**
 This is a clear statement of how your organisation will contribute to that imagined future – again, described in terms that would make people keen to contribute. Where the vision statement must be poetry (hairs on the back of the neck), the mission statement must be prose: the greater the hard-edged practical clarity, the better.

"We will be the biggest producing theatre company in the North of England."

- **Customers**
 This is a clear definition of the categories of customer you are serving, or intend to serve, and a clear exposition of what they want and need. The more sharply the customer types are defined, the better. For most organisations, the best way to answer this question is to start with the profiles of those who actually use you. It is almost always easier to retain existing customers than to win new ones, however uninspiring that existing customer set might be.

 "Our core customers are: (1) educated, traditional culture vultures from within the city region; (2) short stay tourists on weekend breaks; and (3) school groups and A-level students."

- **Proposition**
 The proposition results from cross-referencing the mission with the customer groups. It is a clear statement of how what you do adds value to the people you do it for.

 "We provide high quality performances of well-established plays by focusing on contemporary themes and attracting the best young theatrical talent."

There is a tendency for culture organisations to be over-inclusive. It is possible to be too consultative in the strategy and in the way it is determined. However admirable inclusivity might be in theory, an organisation does need to understand who its core audiences are, and why they care. It may also be understandable that a culture organisation

should try to include as many stakeholders as is possible in its strategy process. But this will lead to strategy with an unimaginative, lowest common denominator content. The principal roles of the organisation's board, or its equivalent, are to determine strategy and to appoint the management team to deliver it. The board, if they are wise, take customer and stakeholder considerations carefully into account. But they do not abrogate responsibility to these groups.

Business Fundamentals

Armed with a clear strategic intent, the culture organisation is in a much better position to ensure its business fundamentals are in good shape.

For a culture organisation, we identify just four such headings. These headings apply to pretty well any culture organisation. They are not comprehensive: they do not, for instance, directly address the creative process that is the heart and soul of many culture businesses. But they are the headings that make the difference between a successful culture business and an unsuccessful culture business – *as a business*, which is our primary concern here.

These four business fundamentals are:

- **Shows**
 Generating footfall and revenue from the main cultural products;

- **Public Good Funds**
 Securing financial support from the public purse, from foundations or from individuals, in support of the organisation's mission;

- **Trading Activity**
 Generating profits from activities alongside the main cultural products, e.g. from merchandise, space, refreshments;

- **Asset Management**
 Using cultural and other assets (e.g. buildings, collections) to best effect.

In all cases, this section addresses only those aspects of each of these headings, which are drivers of enterprise and resilience.

Shows

Building Identity

To put on great shows (whether exhibitions or performances) the first thing to think about is **time**. We live in a short-term, fast-results era. Paradoxically, we are living longer than we have ever lived, whilst forgetting what our grandparents knew about thinking long-term. We think that success is about speed, because the most compelling tales are all about overnight transformation. But such stories are the statistically insignificant exceptions: most solid progress is the result of long haul persistence.

So, a culture organisation should be ambitious but long-legged. It must think about taking an audience on a journey that will span many events over many years, building their loyalty, changing their lives. It must have a clear sense of the kinds of people who will make up that audience, of how their relationship with the organisation can deepen, and of how the themes and phases of the journey will build on and link to each other.

A culture organisation should be *creative* about how this is done. To build an audience is not primarily an analytical task, though audience analysis can be a useful contributory input. It is an essentially creative task: we are imagining a future full of vibrancy, challenge, and development. We are zooming in on the imagined components: the people, the shows, the spreading word of mouth. And we are capturing all this in a set of words that speaks to the hearts of all those working with the organisation.

From this description of an imagined future, we are then distilling the core electricity that sparks and sizzles through everything we do. Not a dry, formulaic mission statement, but a real sense of *mission*. We are building, together, a word picture of the organisation's character and offer.

Now, this **identity**, this proposition, this mission; it has to be made to work for its living. It must bed in across all that we do and all the people who do it. Clarity of purpose: this is the most fantastically powerful tool available in the management toolbox. If the people buy into the purpose – really buy in, with their hearts and minds – much of the tedium of organisational life (addressing underperformance, dealing with poor customer service, resolving intractable

problems...) evaporates. And, what is better, we feel good about ourselves.

Identity is not fixed. As individuals, our sense of who we are changes over time and, in any case, differs from what others think of us. Culture organisations need to establish a clear identity, but they need to do so in a way that allows that identity to flex and be challenged over time, not least by what audiences tell them through their feedback or their wallets. Go back and look at the strategic intent section for more on this theme.

Snobbery of Ideas

In many culture organisations, a small set of people – not always the obvious suspects – have a stranglehold on the programme. They generate the ideas for new shows and events, they prioritise those ideas, and they sign off the delivery plans that make them real.

This may work; it may work well.

It may result in a self-indulgent, unimaginative, unedifying, and uncommercial output.

A consistently successful alternative uses the enterprising approach to ideas set out in an earlier section. It ensures there is a culture of innovation: that people hear what the audience is saying they would like to see; that we are sharing and copying show ideas with and from others. It builds strong ideas and behaviours in the organisation – generating, filtering and prioritising possible shows. It ensures that show ideas are only pursued where there is good knowledge in

place (of costs, customers and competition) to guard against the unnecessarily unexpected.

Crucially, from a strategic perspective, an effective culture organisation is one in which the organisation's identity, purpose or proposition permeates all this. Knowing who you are, and what you are for, means that you will pick up ideas from the right audiences, copy them from the right fellow travellers, and learn the right new things from the ashes of the old. It means that you will challenge the pedestrian or self-serving ideas being touted by the powerful. And it means that you will prioritise those show ideas in a way that not only makes immediate operational sense, but that also makes long-term strategic sense.

It is worth dwelling a little more on the specifics of a show idea. It is not unusual to find that key people in a culture organisation have very different understandings about the exhibition, production or event they are planning. There may be such a rush to get on with the hard work of making a good idea happen, that the really important hard work – defining the proposition – has not been done. What is the elevator pitch for this show? Who is it aimed at, why will they like it, and how will they decide they will spend their time and/or money with us rather than going out for dinner, buying a DVD or buying a boat? Do we really understand the tone of

the piece, and whether it will play well to the audience we are aiming at? Have we identified our key marketing message, and the communications channels by which this message will connect appropriately with the target market?

Robust and Risky Filtering

There is much more to settling on a programme than looking for alignment with organisational mission and identity. Most shows must pay their way financially. In all but the most public-money-favoured culture organisations, the money made by the programme is essential to survival.

Culture organisations may get in quite a muddle over this. Even the words can be unclear: what do we mean by profit, income, net income?

In reality, it need not be complex; and good organisations shape their management reporting so that it is clear for all concerned. The direct costs of a show are those costs associated with putting it on, over and above any costs we would have carried had we not put it on. The income from a show is the income we only had, because we put it on (e.g. ticket sales). The difference between the two is the "contribution" the show makes to the organisation, and to the organisation's fixed costs (e.g. premises) after any grants received. We need sufficient contribution from all the shows we run in a year to cover those other costs. So we need to work out how much money a show will bring in, and how much it will cost, to see whether it should fit on the priority list.

But what about the fact that shop and café sales may go up as a result of the increased footfall generated by a show? And what about if we are looking at a themed series of five shows, and employing a coordinator for that theme? How do we filter shows in or out given this financial complexity?

The truth is that there is no right and wrong way. Accounting is more interpretative than most people recognise. Part of the answer is not to look for truth (there are always multiple truths in accountancy), but for simplicity, consistency, and an accompanying narrative that rings true. The other part of the answer is to make a distinction between how you plan and how you manage. It is sensible to build a business case for a show based on direct (e.g. tickets) and indirect (e.g. café sales) income. But, once the show is operationalised, you would not normally expect the show's project manager to take responsibility for café performance.

The business case for a show should indicate how much money it will make the organisation. This figure should be a key determinant of whether the show is included in the future programme and the level of management attention and investment it receives.

But there are two other important factors. The first is risk. No business case is certain, because it deals with the future, which is never entirely predictable. When evaluating a show's business case from a risk perspective, a successful culture organisation will pay close attention to the predicted audience numbers. A show's advocate will be tempted to predict audience sizes at the top end of what is possible; a culture organisation leader will want to know the financial consequences of them ending up at the bottom end. A

compromise is only achievable by reference to the audience numbers experienced with similar shows aimed at similar audiences. The other key risk factor is the delivery team; the set of people proposed to see the project through to completion. Successful culture organisations will want to know that the team is based around grounded, completer-finishers, rather than financially irresponsible visionaries.

The second important issue is integrity. Frequently, the culture organisation will find that the most compelling show propositions from a financial perspective (the dinosaur exhibition, the pantomime) are the least compelling from a cultural perspective, and vice versa. Culture organisations may struggle to navigate this seemingly irreconcilable tension.

The answer is almost always to refer back to the themes we explored at the start of this section – that of time and identity. A poor quality, highly populist show may look like a good financial proposition this year. But if it fundamentally undermines target audience support, such that other shows underperform, then the immediate financial gains may be outweighed by the losses on those other shows over a five or ten year period. This risk would need to be quantified and factored into the business case. On the other hand, a high-brow show, which will attract only very small numbers of the cultural elite, may look like a

feather in the cap for the organisation, but if it contributes to a financial loss for the year, the organisation may have no future in which it can wear that feathered cap.

It is not unusual for culture organisations to prioritise integrity over financial return; to put perceived cultural value ahead of cash, and prioritise shows that are determinedly not populist. In practice, such an attitude is often a mask for a self-serving snobbery about what is and is not "good art". Good cultural organisations are, at all times, explicit in their decision-making about integrity, populism, and the need for a long-term balance between financial viability and cultural challenge. The very best organisations use innovation and managed risk to reconcile cultural integrity with financial performance, and see no need to trade off one against the other.

Funding for "Public Good"

In the UK, we have grown complacent about public money supporting culture. We treat it as a right rather than a privilege. As a consequence, it is not unusual to see culture organisations being resentful when funders request that they make a case for receiving funds, or that they achieve specific outcomes in exchange for getting it.

There is a hard-edged reality here. Culture funders, be they national government, local government, or foundations, have their own purposes, plans and stakeholders. They want to know that their money will achieve results consistent with their aspirations. Almost inevitably, therefore, they will create some form of specification and ask the culture organisation

to demonstrate how it has met it or will meet it. It is not unusual for this specification to be instrumentalist; to assume a much clearer cause-and-effect connection between activity and outcome than is possible in the cultural sphere. Broadly speaking, effective cultural activity helps create the conditions for socio-economic success. It does not create many jobs, for instance, but it helps attract and retain those that do. It does not result in many new qualifications, but it helps to open the minds of those who do become qualified.

So, as far as funding is concerned, there are three key questions that culture organisations should ask themselves. The first is the big one: *do you want this money*? It is important to be aware that, in taking the money – or even in pursuing it – you are likely to change the shape of your organisation. Why? Simply because you will be taking on, or needing to look like you are taking on, objectives that may not be the same as your own. This does need to be understood before a decision is made about a funding application. The audience of an effective culture organisation gives it its *right to operate* on the basis of its artistic vision. The pursuit of public or foundation funds can erode this identity, and the audience support it generates, potentially resulting in a soulless and irrelevant automaton.

If the decision is made to pursue such funds, good culture organisations ensure that the pursuit is consistent with organisational identity. They are clear about what funds agreements they will pursue, in support of which aspects of their mission. They will make compromises, if need be, with the funder's objectives and reporting arrangements, but they will not compromise their values and reasons for existing. They will not whinge at the funder or potential funder: if

there is a mismatch of approach – a fundamental mismatch that would undermine what the culture organisation is there to achieve – they will attempt to negotiate through the mismatch or agree to walk away. Whingeing culture organisations do not last the course.

So, assuming that the decision has been made to pursue the external funds, how does the culture organisation maintain and strengthen the relationship with the funder? There are two basic rules. First, get good at jumping through that funder's hoops. They have invented those hoops for a reason, so put your head down and answer the exam question. Second, influence the shape of the hoops so that your hoop-jumping is better than anyone else's. What does that mean? It means careful stakeholder management, judicious persuasion.

Excellent culture organisations help their funders to understand that the socio-economic case for culture is both imprecise and extraordinary. They do this not by bashing stakeholders about the head, but by finding the issues and language the other party cares about, then showing (demonstrating, as only culture can) how culture delivers against those issues, using the stakeholders' language. Excellent culture organisations know that they are, fundamentally, in the relationship business – and they invest heavily in creating mutually supportive relationships with key stakeholders.

Culture organisations should take care not to limit their thinking on what funders may fund. Different organisations have different objectives and philosophies; all of the following may be supported by one party or another:

- Shows and exhibitions;
- Associated events;
- Core activities and overheads;
- Digital products;
- Digital projects;
- Digitisation projects;
- Specific commissions;
- Specific acquisitions;
- Significant change programmes;
- Audience development initiatives;
- Capital development programmes;
- Capacity building.

One specific area has received particular attention in the last few years: public sector commissioning. A commissioning fashion has swept through many parts of public service; the idea that public services may be best structured on a commissioner/provider basis: that a local authority, a government department, or a particular public service function should specify what is required from a service, then contract others to deliver it. The approach is seductive but flawed, though such an analysis takes us beyond the scope of this text. Nonetheless, culture organisations have seen that it presents them with an opportunity: a chance to demonstrate the value of culture in addressing the particular objectives of health, education, or social services commissioners.

They are right. But – and it is a big "but" – there are practical obstacles. Most commissioners are strapped for cash, with their funds inevitably tied up with big delivery programmes that have existed for generations (such as care homes, hospitals, social workers). They have a well-developed analysis and vocabulary, allied to an instrumentalist management

context, which does not connect well with the diffuse and imprecise nature of cultural sector outputs. And culture organisations usually have little capability or capacity when it comes to the long-term relationship management required to overcome this fundamental difference of perspective. Many promising connections between commissioners and culture organisations have failed as a result of a senior culture player telling commissioners that they "ought to fund us", and the commissioners, quite understandably, resenting being told that, in effect, they don't know their own specialism.

Commissioning can be a useful income stream for a culture organisation. But it is unlikely to be substantial in size, especially in the short-term; it will come with onerous delivery and management information requirements and can completely reshape the identity and operation of a culture organisation. It should be pursued with care.

Trading Activity

Culture organisation should see their core offer – their shows, exhibitions, events, assets – as a honeypot, bringing in an audience. This is the first and prime task: to make something wonderful happen for people.

There is a secondary task that relies on the honeypot. That task is to offer additional products or services, and to make money off the traffic that the honeypot attracts. It is a secondary task, and it is often treated as in some way of lesser status, but it is usually financially crucial to the continued existence of the organisation. Where it is seen as being of lesser status, its voice will go unheard in key management

decisions. The shop and the café may keep a museum or theatre in business, but how often is the shop or catering manager asked to help guide programme choices; to identify which show is likely to generate the better revenue?

Successful culture organisations ensure, from the start, that they are thinking in the right way about the relationship between the primary and secondary activities. They recognise that part of the offer for much of their audience will be about their secondary spend: that audiences may come as much for the coffee and the merchandise as for the show. This may be a humbling message for directors, creatives and curators, whose aspirations may be culturally lofty and refined, but it is the reality for the vast majority of culture organisations. Such folk must be ready to explore and exploit commercial parallels – for instance, with retail. Supermarkets may offer the staple products (bread, beans, milk) at below cost levels. They do this to attract customers, knowing that, once they are in the store, there is a good opportunity to sell them a range of higher margin products. This is the loss leader philosophy. Some heritage attractions and museums, for instance, do not charge for admissions: this is – or could be – a loss leader strategy. Magazines and newspapers are another valid parallel: many such journals only exist because the content generates circulation figures, which generate advertising revenue. It is worth asking which of the continually changing techniques used by magazines and supermarkets can work for a specific culture organisation.

The core culture organisation trading revenue streams, in addition to standard tickets or admissions, are shop, café, and donations. Successful culture organisations (1) see

their core product or show as a honeypot; (2) ensure the intended audiences feel the pull that it exerts; (3) make it as easy as possible to decide to move down a funnel towards that honeypot; and (4) give them opportunities all along that funnel to enrich their experience by spending additional money. The business of buying an advance ticket, for instance, will be as painless as possible; and will be accompanied by the opportunity to pre-book dinner or drinks in the café, to order a programme to go with the tickets and perhaps a small gift for any guests, and to donate to the refurbishment appeal. Having arrived at the venue, the customer's journey through the facility will be enhanced by merchandise offers that complement the known profile of the customer, by a café ambience that does the same, and by personable staff who lift customers' self-esteem by giving them a chance to make a donation to the continued excellence of the organisation itself. The key point is that people go to culture organisations to be entertained and to feel good about themselves: secondary services and products can and should be positioned to help them achieve these objectives whilst also generating profit.

It is worth adding a cautionary word about online shops. Too many culture organisations live in hope that their online shop, and their digitised assets, will provide a huge and almost cost-free revenue stream. The evidence is not good that this will happen. Online customers are unlikely to pay a premium to buy products they can buy cheaper from other online outlets, and any bespoke objects are unlikely to sell in the volumes required to make large amounts of money. There are so many digitised assets in global circulation that any one collection is unlikely to generate massive interest.

That said, an online presence is, for most culture organisations, a necessity. Location, programme, admissions – these now ought to be visible online. An internet presence may also offer a useful channel commercially to exploit the organisation's brand, if it has a powerful branded identity. But this initiative would be best approached as a coherent commercial strategy to build and exploit such a brand through all channels, rather than just as an online endeavour.

It is also worth dwelling on the use of space. Many culture organisations are realising that their theatres, exhibition spaces and offices can be attractive venues for business meetings, invitation-only events, and even weddings; better than faceless hotel or corporate venues, lending character and interest to the occasion. To work well, the accompanying package needs to be right: catering, PA systems, front of house, licences, and insurance. The smart culture organisation goes further than this. It thinks about potential room hire customers at the show or exhibition stage planning phase. It ensures that the space is deployed, not only for the primary customers (the theatre audience, the visitors to a temporary or even permanent exhibition), but also for a potential room hire customer. This may mean, for instance, building greater portability into flats, props or cases.

So the watchword is coherence; ensuring the programme is informed by and informs the secondary commercial activity. And there is a wider need for coherence, in relation to the other enterprise support functions, which are often part of the mix: front of house staff, the education support function, asset or collections support professionals. In short, if these folk do not understand the importance to the organisation (and their jobs), of commercial revenue streams, of whom

the organisation sees as its target markets, and of how we are aiming to build and develop relationships with that target market, the organisation will, at best, miss out on some well-informed innovations and, at worst, will provide a poor and diminishing service. Enlightened cultural leaders don't protect and cosset their artistic sensibilities from filthy commercial considerations – they develop a vision for the organisation that reconciles the two, then they actively communicate that vision across all internal functions and beyond.

Above all else, though, management information is the most under-developed enterprise theme in culture organisations generally. It is a dull topic, for sure, but many management teams are flying blind, with an inadequate understanding of the basic financials, let alone the relationships between, for instance, marketing spend and demand, or the volume and profile of segmented target markets. Good management information underpins all other aspects of cultural enterprise.

Good management information is not perfect information. This is one of the issues getting in the way of culture organisations taking control of their own destiny: it seems that no one piece of information they receive is ever quite right. A successful culture team, like any other successful management team, adopts a parallel approach to information: uses the best information available to make decisions, tested against common sense, intuition, and a personal investment in listening to customers – while continually improving the quality of that information for future reference. And a successful culture team is well aware of the Pareto Principle. This states that, in any given circumstance, a majority of the results come from a minority of the activity. It is also known

as the 80-20 rule: for instance, that 80% of sales come from 20% of customers. Good commercial discipline is not about doing everything: it is about focus – identifying what actions or customers or productions will produce disproportionately big results, and doing them well.

Asset Management

In addition to their buildings, many culture organisations are the owners or valuable tangible and intangible assets. This is most obviously true of galleries and museums, but the vast majority of culture businesses will own their logo and other brand elements that could be developed and exploited.

Assets may be listed in the following groups:

- **Collections** – artefacts, objects, works;
- **Fixed** – premises, show/display specific, equipment;
- **Intangible** – skills, goodwill, networks.

Working through each group, the following sequential questions should be asked:

- **Customer focused:**
 o Which customer groups should the asset serve?
 o Does the asset present the opportunity of building an ongoing relationship with customers?

- **Identity consistent:**
 o Does the asset match the identity and proposition of the organisation?

- o How can the story of the asset be told to target customer groups in ways that support the organisational identity?

- **Efficient & productive:**
 - o Does the asset have potential for attracting significant new audience numbers?
 - o Are there opportunities for generating commercial income from the asset?

This assessment should generate a range of further questions, clear opportunities, and a number of issues. The enterprising management response again uses a Pareto approach: it quickly identifies which of the themes arising will give the best return, and prioritises accordingly.

Typically, there is a choice between three action options per asset. The asset may be (1) *exploited* (to generate greater return); (2) *contained* (to reduce cost, or at least to restrain a growth in cost); or (3) *exited* (to realise value or reduce liability). Many culture organisations end up hoarding their assets, which may be both costly and distracting.

A provincial museum is interested in assessing its geological collection. Most of the collection is held in storage. Observation shows that those items that are on display receive very little attention; there are only a handful of requests per year to see items in the store. The target customer groups – short-stay visitors and schools – are more interested in the museum's emerging focus on the medieval period and on contemporary art. There appears to be limited new audience opportunity associated with the specific objects. From an efficiency perspective, the best approach may well be to permanently

loan the items to a museum with a bigger collection, and a greater geological focus.

A well-established theatre company has many hundreds of costumes in storage and a costume manager with a deep knowledge of fabrics, fashion, and dress-making. The organisation has identified "Jane Austen TV-watchers" as a focus for its audience development. There is a strong possibility that the combination of costumes and expertise would appeal to this audience, potentially supporting the drive to attract such people into future theatre productions. The stores could be opened for guided coach party visits for limited periods, generating a small profit (after costs of overtime), but also generating a mailing list of potential new theatre customers.

SECTION 2

Getting Change Going

4 Reviewing the Customer Journey

The Visit Cycle

A typical customer goes through a number of steps leading up to and completing a visit. Enterprising culture organisations see one customer visit as simply a single cycle in that individual's continuing relationship with the organisation: they look to manage the customer cycle, rather than just one visit or one "customer journey".

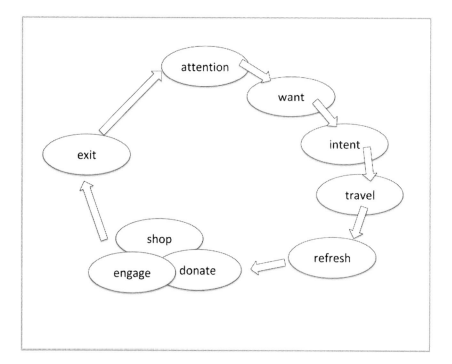

When the potential visitor is outside of the walls of the culture organisation – whether he or she is a repeat customer or not

– there is a marketing task. We must, in short, make them think about us (*attention*); turn that attention into desire (*want*); then turn the desire into a plan to come (*intent*).

Having made the journey to us, we should provide them with the chance to give as much as they are willing and able to give, as they pass along the funnel to the honeypot that is our core cultural product. They should first have the opportunity to be fed, watered and toileted (*refresh*), before being ushered in to the heart of the trip: their chance to be transformed by a cultural experience (*engage*) and to take some of that excitement home with them in the form of products (*shop*) or personal alignment with our cultural values (*donate*). They must then be given the opportunity to leave in a way that makes it clear we care about them and their return (*exit*).

It is a Saturday and a family is shopping in town. The museum is 400 metres from the main shopping street. Its first task is to get attention where the family is likely to see it: a poster outside McDonald's?

She has come into the art gallery to kill an hour before meeting friends. She sees a sign on the back of the toilet door, advertising a curator-led workshop on Pre-Raphaelite art. She knows her friend is a fan and thinks about buying her a ticket as a birthday present. She forgets about this as she looks at the exhibits, but, as she heads for the exit, is reminded when the assistant asks her whether she enjoyed her visit, and pays on the spot.

It is midweek and a middle-aged man wants to take his wife out on Friday night. Before he leaves the office, he goes online

to look at his options. His local theatre is hosting a touring production of Alan Ayckbourn's new play this week. Their first task is to ensure he sees them in the first page of results he sees when he Googles "local entertainment" options.

5 Change Management

A basic but powerful change model says that real and sustained change will only work where the people involved experience three conditions:

- Discomfort with the current state of affairs;
- A compelling vision of the new future;
- Clarity concerning the first steps that should be taken towards that vision.

Leaders of successfully changing culture organisations ensure that their people feel all three.

Unsurprisingly, given most people's desire to be nice to each other, the one that is often neglected is the first: people must be helped to feel unhappy with the status quo. They must also be allowed to appreciate that **change is possible**. There are many in the culture sector who find their organisational context ineffective or even toxic, but who simply do not believe anything can be done to change it. All the management talk in the world will not change this belief: what is needed is evidence. Once people see that small changes are happening in front of their eyes, they will start to believe that major change is achievable – and may even help make it happen. This is why clarity concerning first steps is so important. And the vision element is perhaps the most important of all: typically, people who work in the culture sector believe in what they are doing. They want to feel that the organisation to which they give their loyalty has

an identity and sense of mission. They will put up with any amount of privation if the cause is good.

So, for a culture organisation to become more enterprising and sustainable, it may need to undertake two initiatives. The first concerns **strategic intent**. It helps the organisation's key people and stakeholders to clarify identity, purpose and ethos. The second, which might be called **enterprise development**, helps the organisation start to feel uncomfortable in its comfort zone, and take steps in the right direction.

Strategic Intent

We discussed this conceptually earlier in the book. To turn the concept into black and white specifics, three elements are needed:

Theme
What outside world theme is the organisation really concerned about? This could be education, employment, health and well-being, equality, beauty – any one of a range of important human topics. Note: these are not culture sector-specific themes, but wider issues of concern to humanity.

Impact
Within the selected theme, what impact do we plan to have? If the theme is education, for instance, we might hope to raise young people's achievement levels. If it is employment, we might perhaps hope to stimulate creative industries. If it is well-being, we might simply want to help more people laugh, cry, and connect.

Positioning
This final element indicates what the organisation's role would be in achieving the specific impact(s) within the chosen overall theme(s). It might be, for instance, "by making Shakespeare relevant and accessible", "by providing high quality space for emerging talent", or "by bringing our heritage alive".

Here's an example for a museum.

We want to raise aspirations and increase employment **(these would be their priority themes)**, *reducing local inequality to UK average levels and doubling the size of the local creative sector by the end of the decade* **(this is impact)** *by turning our industrial heritage into an innovation engine for the local economy* **(this is the positioning)**.

An alternative might be as follows.

We want to build a strong local sense of identity and loyalty **(the priority theme)**, *contributing to the positive outcomes in health, crime, and education that are a consequence of greater social capital* **(impact)** *by celebrating our shared and diverse culture* **(this is the positioning)**.

Whatever the specifics, what is important is that the content is hard-edged and meaningful. It is better not to have vision or mission statements that are wishy-washy at all, than to advertise the fact that you really don't know why you are in business.

So how do you establish a powerful, strategic intent that works for your key stakeholders? There are essentially two routes. The first is that the organisation's leader (the Director, Chief Executive or, possibly, the Chair) simply sets out his or her theme, impact and positioning statement, and dares other players to disagree. This can be a remarkably effective and efficient approach if the leader has the right combination of arrogance and humility, and is able to use words well. It is also potentially explosive: it runs the risk of exposing the fact that the leader is out of sync with other important players, leaving that leader few options but to leave, attack, or make a shamefaced climb-down.

The second approach is more consensual or, at least, flushes out any divergence of view before taking the sting out of the situation by offering a number of options. It starts with the leader, or a team supporting the leader, **assessing** the current state of play. This means getting a sense of what stakeholders (including current and target customers) want, pulling together a robust assessment of the organisation's existing resources (its strengths and weaknesses); looking at where partners and influencers are heading; and keeping an eye on the wider socio-economic context.

This assessment phase feeds into an **options analysis** phase. The information gathered allows the creation of two lists. The first is a list of all possible strategic directions (preferably set out in the theme/impact/positioning format). The second list sets out this organisation's strategic success criteria. These success criteria specify what qualities its strategic direction must have in order to work – for its specific stakeholders and in light of its specific strengths and weaknesses.

The strategic intent options can then be evaluated using the success criteria. This will generate a shortlist of options that can then be taken through whatever decision processes (e.g. board, community consultation, stakeholder consultation) are necessary in the eyes of the organisation's leader.

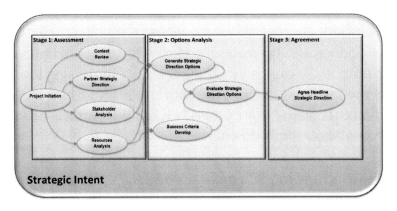

To make this less conceptual, look again at the earlier museum's example. Two different strategic intents were set out. If seen through into practice, they would result in the organisation heading in very different directions. How should the museum decide between them? This is where the strategic success criteria comes in. Imagine a scenario (scenario A) in which the museum is owned by the local council, has no prospect of becoming independent, and is an area of post-industrial high disadvantage. The museum might determine that its strategic success criteria should be as follows:

- Visibly aligned with local political priorities;
- Focused on economic growth imperatives;
- Building on our historic strengths.

Or imagine a very different scenario (B). In this case, perhaps there has been a history of inter-community tension,

the council is strapped for cash, and it is not particularly concerned about directly owning the museum. In which case, the success criteria might simply be:

- Focused on increasing commercial revenues;
- Allows quick decision-making and market responsiveness;
- Creates links between people and communities.

If scenario A's success criteria were applied to the two strategic intent options, the first would, most probably, score higher. If scenario B's criteria were applied, the second option would likely be preferred. In either case, the museum would be giving itself a clear, relevant, and supported proposition around which its future could be built.

Enterprise Development

This is an approach to "unfreezing" a culture organisation, allowing it to move with speed towards a more sustainable approach. The change project can work, whether led internally or by external consultants.

The methodology for achieving this successful enterprise/commercial momentum comprises five elements:

- Project inception;
- Early focus;
- Internal alignment;
- External alignment;
- Embedding.

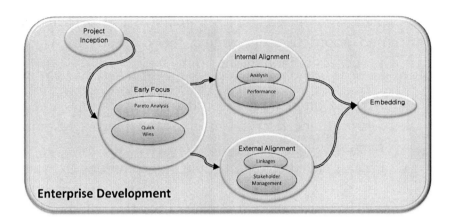

Enterprise Development

Phase 0: Project Inception

If the project team is internal, ideally it would be three to four people in size, drawn from a cross-section of functions/ management levels. The team would work with the Director to map out and clarify project focus, phasing, and resources. This phase results in an agreed scope and project plan to deliver the project. The project plan should be used by the Director and project team to monitor progress against the agreed milestones.

Phase 1: Early Focus

This phase comprises two elements:

- Pareto Analysis;
- Quick Wins.

Pareto Analysis

As discussed earlier, the Pareto Principle states that, in any given circumstance, a majority of the results come from a

minority of the activity. It is also known as the 80-20 rule: for instance, that 80% of sales come from 20% of customers.

The first element of the project is a review of the current state of play across the service. The basis of this analysis should be the first three chapters of this book: it uses those concepts to explore the extent to which the organisation is **balanced**, **flexible** and **strategic**. Given that this comprehensive assessment can be quite an undertaking, those organisations in a hurry may want to focus on the flexibility element only, using the concepts set out there to determine the major structural issues across the organisation and within specific functions.

Having performed a comprehensive critique, using these tools, a quick and dirty Pareto analysis should follow. Taking each of the biggest problems and strengths in turn, the team should establish, using both analysis and intuition, a view on which are: (1) **Significant Return** opportunities (giving the best potential financial results); and (2) **Quick Win** opportunities (likely to demonstrate swift commercial benefit, even if not of enormous scale).

The table below shows how the opportunities will be categorised, based on the scale and speed of return. This enables a better focus on the opportunities that have most impact.

	slow		quick
large	5 yr plan	3 yr plan	initiate
	hold	3 yr plan	initiate
small	reject	hold	test

scale of impact

speed of impact

Quick Wins

It is important to recognise that this is an action project, not a paper-planning project. Typically, the organisation as a whole needs to see real things happening successfully at an early stage if it is to believe in what can be achieved. A proportion of the Quick Wins identified above should be initiated as soon as the Director or Chief Executive has signed them off. The objective here is more about demonstrating culture change than about making money, though that need not be explicit. The project team will typically have an important role in helping identify a lead person for each Quick Win, and in supporting them to make the required changes.

Even relatively small-scale advancements (e.g. an increase in secondary sales, or the removal of a political blockage) can have significant positive impacts more widely across the organisation, as people see that change is possible. Having identified, and gained support for, potential Quick Wins, the team then works with the organisation to realise the financial and motivational advantages of making them real.

Milestone: The service should expect to see tangible, commercial success at an early stage, an increased sense amongst staff that change is possible, and some discomfort being felt amongst those entrenched in existing ways of doing things.

Phase 2: Internal Alignment

This phase comprises two components:

- Internal analysis;
- Performance improvement.

Internal Analysis

This phase focuses on the most promising significant return opportunities identified in Phase 1. This is a more effective approach than trying to address all the organisational issues/opportunities. "Sheep dip" organisational culture change programmes can be exhausting and unhelpful: this approach takes a focused and pragmatic stance, addressing specific, tangible issues or opportunities. By so doing, it inevitably infects the organisation with a more hands-on, less cerebral approach to making progress. In our experience, enterprise culture change is best achieved by demonstrating that improvement is possible; by reducing unwarranted political interference in decision-making; and by findings ways of empowering the most energetic and insightful members of staff.

The team asks key departments within the organisation to look at the identified Significant Return opportunities and to obtain the necessary performance and financial information,

identifying the blockers and enablers to progress. The information required also includes details of staff and associated costs and major supplier contracts.

In so doing, the team also looks at the processes that surround this information: the way in which it should be used continually to improve performance. Experience suggests that culture organisations may be effective at collecting data, but not necessarily so skilled at interpreting it, and understanding what actions are needed to improve customer and financial performance. It is not unusual to find inappropriate non-executive or political interference in operational decision-making to find that there is no connection made between customer and financial data, or to discover that front-line staff have a range of good ideas that fail to filter through to senior management.

Performance Improvement

Having identified specific pressure points in the internal machinery of the service, the team works with key officers to take the actions that will improve enterprise performance.

Typically, this work includes a significant focus on the alignment and effectiveness of the financial/customer satisfaction performance management regimes.

Once real progress starts, it can run out of steam if organisational and management behaviours do not keep pace. This phase of the programme assesses the risk of this happening, identifies the high-risk blockers, and creates a bespoke programme for each department to address the

issues. This may include bespoke training sessions and mentoring with key groups of staff and senior managers.

Milestone: This phase results in a clear performance improvement plan, and clear progress on that plan.

Phase 3: External Alignment

This phase comprises two components:

- External linkages;
- Stakeholder management plan.

External Linkages

Having demonstrated to the organisation as a whole that positive change towards an enterprising approach is both possible and desirable, and having proved that it works through early successes, we need, in parallel, to develop the longer-term and sustainable financial model by optimising partner and stakeholder input.

This phase of the project focuses on the Significant Return opportunities identified in the Pareto Analysis. The project team explores how these enterprise themes can be developed, where necessary, in conjunction with commercial partners and stakeholders.

Stakeholder Management Plan

The team develops a management plan to approach these external players. Typically, this would include suitable business partners that see the benefit of accessing the

organisation's assets/customers, and who are willing to invest in the establishment of the new line of business in exchange for a share of the reward.

Milestone: This phase results in a well-defined set of commercially supportive relationships.

Phase 4: Embedding Change

This project phase ensures that the new enterprise culture is embedded with staff and supported by the necessary information and management processes.

The specific activity required emerges during the previous work. It may include staff changes, one-to-one support for specific managers, and possibly further enterprise skills development sessions. It ensures commercial partnerships, other enterprise opportunities, and performance management processes are embedded for the long-term. The objective is to focus on a continual improvement in customer satisfaction and financial returns; and to ensure that all stakeholders in the organisation support this driver and understand its relevance to the vitality of the organisation and to its cultural, as well as financial, mission.

Milestone: As part of this work, the project team develops appropriate performance and accountability measures in conjunction with senior management to ensure continuous improvement takes place.

SECTION 3

Best Practice – Shows and Programming

6 Programming Best Practice

Approaches to programming vary, as do the level of their success. Success in programming results from a balanced reconciliation between two quite different perspectives or drivers:

- **Organisational:**
 the culture organisation's vision, identity, political positioning;

- **Individual:**
 the perspectives of those involved in curating a programme, stakeholders, project managers.

Typically, there will be a perspective that outweighs the others, which can lead to a programme that impacts on very few of the success criteria, or which is unsupported by key staff. Alternatively, a programme can be the result of many perspectives competing for priority; the unfortunate effect being a programme that tries to please everyone, but in reality, pleases no one.

But what is success? Is it artistic excellence? Educational excellence? Academic profile? Visitor numbers? Return on investment (RoI)?

In the current climate, a programme's commercial success is of increased importance. We are looking here at how the commercial perspective can be balanced with other considerations.

Ideas Generation

The most obvious starting point to build any programme is ideas. The truth is that ideas are ten-a-penny: the clever bit is to capture and filter them. Enterprising culture organisations have a strong process for capturing ideas. They should be generated and collected from all sources; stakeholders, external organisations, partners, visitors and staff. It is important not to rule anything out at this stage; everyone must be heard. Someone may have a great idea that has basis in a source unavailable to the management team, or the programming team, so the net must be cast wide.

So, as we asked earlier: Do we **listen**? Do we **share**? Do we **copy**?

Filtering and Prioritising Ideas

When prioritising ideas, there are several factors to consider and to balance. These are:

- Assets and collections;
- Customer wants;
- Identity;
- Enterprise opportunities.

Assets & Collections
It is sensible to generate and prioritise programming ideas based on organisational heritage, past shows, past programmes, collections, and/or staff strengths. It is also useful to think about networks. Relationships

are one asset form: are there partnerships with others that can be built or exploited?

Customer Wants

For a culture organisation, finding out what its customers want is a slippery task. Often, they will not know until the offer is made.

But the discipline of *thinking about* what particular customer groups may respond to is essential. Bad programming may alienate the very people whose ongoing loyalty is essential to organisational health. There needs to be clear processes in place: processes that ensure ongoing customer engagement; processes that create organisational permeability; processes that ensure that it is not easy to ignore the customer perspective. These processes will vary according to customer group. Some culture organisations, for instance, will depend on the continued support of a small number of wealthy philanthropists. In this case, programming decisions will need to prioritise their specialist or narrow-interest benefits, as well as components that appeal to a wider market.

Identity

Long-term success comes from the development of a consistent offer: an organisational personality that appeals to and stimulates particular audiences and other funders. Programming is the visible expression of the culture organisation's identity. It follows that the best programming builds on the organisational personality that has been developed over time. It may not be a slave to that history – it may even seek to

challenge the box into which it has been put – but it will take that past into account when planning to do so.

So the organisation should spend time thinking about the journey of its identity, past and future, and use that thinking to prioritise programming ideas that resonate and capture that excitement.

Enterprise Opportunities
It is important to create a programme that offers the best opportunities for enterprise to take place whilst maintaining integrity.

Some programming ideas will generate better enterprise opportunities than others: sponsorship, funding, merchandise – a range of factors should be brought in to play in prioritising ideas from an enterprise perspective.

Major Projects

Once a priority list of ideas has been determined, the next step is to begin to develop them. Some culture organisations will run with a small number of projects at any one time, some with dozens. A small theatre company will typically have only a handful of projects under consideration, whereas a large museum service may have 40 or 50 in its sights, over a five-year timeframe. At the latter end of the spectrum, some further categorisation is needed to separate out blockbuster projects from smaller scale initiatives. Smaller scale ideas should be progressed with a lighter touch than

major projects. Large projects will require greater investment of time, and a more considered approval process.

Outline Project Plan

This is the point at which you begin to define the specifics of a programme idea. It is not unusual to find that key people in a culture organisation have very different understandings about the programme they are planning. It is therefore important to define the proposition – the elevator pitch. This should clarify the target market, the tone of the programme, key marketing messages, and communication channels.

Beyond that, the outline project plan should comprise a brief assessment or estimate of the following:

- **Risk:** What are the associated risks with this idea? Are they political, operational, or financial? How can they be mitigated or managed?

- **Income:** Do you anticipate this idea has revenue-generating potential? Is it realistic? Are there opportunities to increase income?

- **Costs:** What are the anticipated costs of this idea? Will they be outweighed by the income?

- **Timings:** Is the timeline for implementing this project realistic? Does it align with the required timings of external organisations or partners?

- **Expertise:** Do you have sufficient expertise to deliver this project? Do you need to source

help externally? Will a partnership enable access to further expertise?

- **Dependencies:** What does the success of this project depend on? Are there variables that need to be taken into consideration? Is there an associated risk with these dependencies?

- **Stakeholders:** Does this project align with the wants and needs of your stakeholders? Will there be opposition? Can this be mitigated or managed?

Vet Outline Project Plan

Once the outline plan is complete, typically the project manager's line manager would assume responsibility for ensuring the proposed idea matches with various organisational drivers. It is important that the idea aligns with the intended positioning of the organisation: its vision, its identity, its operational capacity. The line manager should use the following to make his/her assessment of project suitability:

- **RoI**: What levels of financial investment would be required to bring this project to life? Will the anticipated financial returns not only cover costs, but have the potential to generate revenue?

- **Strategic fit**: Does implementing this project align with your strategic aims? What is your vision for your organisation for the future? Can this project help propel you towards it?

- **Risk:** Are the risks outlined in the project plan acceptable? Are there risks that have yet to be identified? Is the proposed risk mitigation strategy realistic?

- **Inter-departmentally aware:** Has the project manager effectively considered the resources available in other departments? Will they have capacity to deliver their elements of the project?

Once the line manager is satisfied that these criteria have been effectively addressed, the outline plan can be passed further up the chain to the management sponsor. The management sponsor will decide if the project can be carried forward to develop into a detailed project plan, or requires further scrutiny.

Small Scale Projects

For projects that require fewer resources or are low risk, the culture organisation may give named project managers greater discretion. Typically, these projects are designed as "additional extras" to sit alongside and complement the major projects of the programme. The purpose of these small-scale projects is to broaden the proposition of the culture organisation, adding extra value and points of interest from a customer perspective; good enterprise. They may be, for instance, outreach projects with schools or care homes; or experimental pop-up shows, as much for publicity as for commercial impact.

Approve Small Scale Projects

The case for progressing them should be built using the same headings as large-scale projects:

- Risk;
- Income;
- Costs;
- Timings;
- Expertise;
- Dependencies;
- Stakeholders.

Define Delegated Programme "Blocks"

Such smaller scale projects would then be bundled together into a block of related activity (e.g. "events in support of the dinosaur exhibition", "outreach activities in support of the new play"). This block of projects can then be reviewed for appropriateness, either by the project manager or line manager. Such vetting would use the same criteria as that used for larger projects:

- RoI;
- Strategic fit;
- Risk;
- Inter-departmentally aware.

From this point, the reviewed small-scale projects can be taken forward for development in the overall project-planning phase.

Programme Plan / QA

The projects, both large and small scale, which have been scrutinised against the controls and have emerged successfully, can now be developed as part of Programme Planning. This is the point at which the successful projects can be brought together to develop options for an overall programme. There are three components in this phase.

Combine Projects and Core Activities

Are there points of alignment between the proposed projects and the core activities the culture organisation is involved with? Can they complement each other in a way that reduces drain on resources or enhances the proposition for customers? Can the projects be adjusted to achieve a greater alignment between them and the core activities? Or can the core activities be adjusted?

Develop Options

With your cache of proposed projects, it is now essential to see how they can be integrated into a single and cohesive programme that not only supports the culture organisation's vision and identity, but is also realistic in terms of the organisation's capacity to deliver within the proposed timescales. This can be a balancing act due to the many variables that will be at play, so it is useful to develop a variety of options for the final programme. Each option will present a different financial, risk, and alignment balance.

Categorise Projects by Sign-Off Level

The programming options may each include a good number of projects. For each option, it can be useful at this stage to cluster the projects by size or risk. This enables the senior team to get a sense of what the approval process should look like for each option.

Inevitably, there will be some projects that do not currently have a comfortable fit within the programme options. This does not necessarily mean that the project is inherently bad, but that it may benefit from further refinement. Any feedback as to why this project was rejected from the programme options should be fed back to the project manager so that their outline project plan can be reviewed. Effectively, for rejected projects, the process begins again.

The programme options containing the successful projects should then be brought to the attention of the Director who assumes ultimate responsibility for sign-off. It is the Director's role to review the options, and decide which are actionable and which may have inherent weaknesses. Options that are not as strong as they could be should be fed back to the Programme Plan / QA process for further refinement or rejection. Once an option is agreed upon by the Director, the project managers can assume the task of planning in detail their elements of programme.

The Director also assumes responsibility for feeding back details on how the Core Activities may need to be adjusted to achieve greater alignment with projects in the programme.

Departmental Core Activity Planning

The culture organisation's normal business planning cycle should identify what levels of resources from each department are allocated to programming and to the projects that make it up.

The level and type of resources available may need to be adjusted in the light of the proposed programme. Any proposed changes will have to be based on a department's capacity to deliver these changes. The departmental management teams should assume the responsibility of deciding whether these proposed changes are feasible. If not, then the programme may have to be adjusted. If they are feasible, and there is capacity for departments to help deliver the projects involved in the programme, the programme manager must move on to the next step; collate project capacity.

Collate Project Capacity

The culture organisation's senior team is responsible for overseeing the balancing act between resources needed for core culture organisation activities and those needed for the programme. The programme manager is responsible for coordinating the information needed to make this assessment. In practice, this means clarifying the following:

- **Staff**: Are there enough staff available to deliver these projects?

- **Expertise**: Is there enough expertise available to deliver these projects? Can expertise be

sourced elsewhere? Will this impact on other elements of planning?

- **Budget**: What are the proposed budgets for the projects? Are they realistic?

- **Assets**: What is the availability of assets required for the project? Are they in a usable condition? Are they in use elsewhere during the proposed timings of the project?

Create Detailed Project Plan

Once programme options have been approved and aligned with available resources, detailed programme and project planning should be undertaken.

There are five key considerations involved.

Critical Path

A critical path allows you to lay out the steps by which this project will be taken from inception to completion. What are they key actions involved in the progression of this project? What are the key project milestones? What order should all these elements be arranged in? It may be useful to break the project down into smaller phases inside which the activities sit.

Budget

Design the budget for your project. It may be that, as circumstances change, the budget must also change to reflect this. If possible, build in some contingency

and be prepared to make adjustments as the project develops.

Timeline

Create a timeline that captures when the elements of the critical path need to be delivered. Again, as the project develops, circumstances may change, so be sure you are aware of which timings are flexible and which are not negotiable.

Stakeholders

If there are likely to be difficulties with stakeholders, these have most likely been identified as part of scoping the project risks. However, it can be useful to have an idea about how you will manage stakeholders. Do you have a stakeholder management plan? Alternatively, are your communication processes suitable for ensuring that stakeholders are both happy and delivering what you need them to deliver? Ensure that stakeholders and stakeholder management are a key consideration of your project plan, and that their perspective and input has been incorporated where appropriate. Do not forget that they too will have a distinct set of outcomes they wish to achieve from being part of your project.

Controls

All these elements should also be measured against a set of standard controls similar to those set out earlier: e.g. Risk, RoI, Income, Costs, Timings, Expertise, Dependencies. Which controls are suitable for your project and are they being actively considered at every decision-making phase?

Once a detailed project plan has been created, it is up to the programme committee to assess whether it is achievable. If not, this will be fed back to the project manager with suggestions for alterations. If it is, it should be formally approved.

Project Implement

Ideas have been generated, plans outlined, projects refined and defined. The project manager can now begin delivery of the projects. Throughout each project, the manager should ensure that the actions and milestones within the projects' phases are being delivered. They should also take responsibility of approving or rejecting their team's ideas or proposed changes, and ensure that the staff involved are clear about their roles what they are expected to deliver.

Project Evaluate

After all the hard work, the programme manager and senior team should look at what worked and what did not work. Were the **risks** defined at the outset realistic and well managed? Are the staff being sufficiently **rewarded** for their efforts? Were the **stakeholders happy** with the way they were managed? Were their expected outcomes achieved? What **key lessons** were learned as a result of implementing this set of projects?

Whatever you learn, whatever you would do differently, whatever was successful must be kept in mind. These lessons will be useful for developing future projects.

SECTION 4

Resilience and Finance

7 Finance and the Culture Organisation

In the UK, it is not unusual for culture organisations to have what might be called a "mixed economy" model. This is a fancy way of saying that their income comes from a variety of sources.

This variety can easily obscure which activities are important and which are not, which ones are earning their keep and which are surplus to requirements. Should a loss-making art gallery run an esoteric exhibition of contemporary art that will almost certainly generate only very low footfall – but which may increase its prestige within the sector? The obvious answer – *no!* – may be wrong, if that increase in prestige impresses grant makers. Should an artist accept a well-paid commission from a corporate client with strong links to the arms trade? Setting aside the artist's moral position on the issue, the commercial consideration is whether the damage done by association with the corporate will be outweighed by the money made on the commission.

Both examples illustrate the fact that there are no straightforward answers. Again, leaving aside the moral dimension, these are issues of commercial judgement; questions that can only be answered by the key players, given the specific circumstances. There are no financial formulae to make the decision.

What the numbers can do is provide a measure of clarity; they can help the culture organisation's decision-makers form a view based on clear and consistent analysis. In the

end, this means they need clarity concerning two themes. They need, first of all, to be clear how their organisation's **financial model** works. And secondly, they need to ensure they have a common understanding of how the organisation should look at **return on investment**.

Financial Model

The human body stays alive if the bloodstream feeds the organs. Blood is not the body's reason for being, but it is crucial to its survival. For a culture organisation, money is the bloodstream equivalent.

Just like the parts of the body, every aspect of the culture organisation has to make its contribution to the purpose of the whole. In financial terms, contribution is income minus direct costs. So the contribution made by the organisation's shop would be the cash received in the tills, minus the cost to the organisation of the products sold and the shop team salaries. At its most basic level, this tells us whether it is financially advantageous for us to have a shop, or café, or fund-raising team at all.

For many culture organisations, the "Show" activity heading makes a negative financial contribution: this means admissions income does not cover the costs directly associated with making the show (or exhibition) happen. As a result, the other activities have to make a positive contribution to close the gap, and also to cover the costs of the overheads (e.g. building costs, heating, administration). This is not a problem, of course, since the shop and café could not exist without the show. The whole thing taken together is the

"financial model" of the organisation. It is a description of how the organisation stays viable. All organisations find their financial models change over time.

Admissions

The single most important revenue generator for a culture organisation is its **visitor flow**. All income types, including grants, depend on a level of customer engagement: it is the factor that drives socio-economic and sponsorship impact, as well as direct commercial revenue.

Visitor numbers drive admission income, though it is important to make a clear distinction between the visitor volumes and any resultant cash. There are some financial models (e.g. the major National Museums, some open-air concerts) that do not charge for admission. But visitor numbers provide them with legitimacy and a demonstrable impact, enabling them to justify the grants and contracts they receive.

So a culture organisation needs to be clear with itself what it is trying to achieve with visitor numbers and admissions income. Here are some possible options:

Admission Option	Explanation	Key issue
Free – competitive	No admission charge because to do so would be out of step with competition	Attracting the categories of people who will spend in other ways, and keeping away those categories of people who will not

Free – political	No admission charge because it is a condition of grant or other funding	Attracting the categories of people who will please the funders (e.g. disadvantaged groups), whilst also attracting the categories of people who will spend in other ways
Free core	No standard admission charge (see previous two options) but charges levied for special shows	Getting the right balance between core offer and chargeable shows so that grant funders and/or core visitors do not feel cheated
Loss leader	Admission charge set at a low level (i.e. below that necessary to cover costs) in order to attract volume visitors	Calculating predictable secondary spend per visitor; making sure admissions plus secondary spend is greater than if higher admission price were charged, suppressing visitor numbers
Profitable	Admission charge set at a level that covers costs	Working out the price/demand curve: setting admission price at a level that optimises the total income. Too high price will reduce demand; too low a price will earn too little profit

Earned Income

Visitor flow makes other kinds of income possible, notably from retail and catering. It is not unusual for culture organisations to see these functions as being essentially parasitic and simple. In practice, they may be neither. A good shop or café can extend the visitor experience and boost visitor numbers, even helping to expose new audiences to the core cultural product. And it is far from simple to establish and maintain a good shop or café: both are specialist disciplines, responding to a consumer who has a very clear sense of what is and is not high quality. The key to success in both areas is to ensure that the offer (shop or café) aligns with the organisation's target market, and that it complements – but is not slavishly limited by – the organisation's overall proposition. There can be products on the shop shelves that are not directly connected with the exhibition or show; but they do need to match its tone and character.

Visitor flow may also generate visitor donations: where the individual feels inspired to put his or her hand in her pocket to support the work of the organisation. This is typically the poor relation of income flows; neglected and misunderstood. In practice, it can be a useful cash generator, although rarely on a huge scale. Success comes from giving attention to two themes. The first is **self-affirmation**. People are motivated to put money in the collecting box because it makes them feel better about themselves. The culture organisation can achieve this by making them feel special if they do ("together we lift the soul of mankind").

The second theme is value appreciation. Particularly where there is no admission fee, a range of devices can be used

to encourage people to make a contribution. The more pedestrian use guilt ("This organisation is a charity and costs £10,000 per day to run"). The more imaginative use reference points ("Give what you think the exhibition was worth to you – e.g. the price of a cup of tea £2.50, the price of a cinema ticket £8, the price of a theatre ticket £40).

Visitor flow is, of course, generated by the core offer (exhibition, event, or production) and how well that offer is communicated to potential customers. For those culture organisations operating out of a fixed venue, the space in which the show takes place also offers income potential. There is a big market in room hire, principally for business meetings. The spaces within culture organisations carry with them a patina of magic, or erudition, or at least of energy: these can be very attractive qualities with which social events or businesses can associate themselves, simply by holding their meetings there. Where there are issues, they are usually internal to the culture organisation – a fear from those charged with looking after the assets that they will be abused or demeaned by contact with complacent moneymen or drunken party-goers. In practice, the tone is more usually reverential than abusive.

Contracts

Culture organisations can earn money through contracts. These arrangements are seen across a spectrum of types. At one extreme, the culture organisation is owned by, or very closely tied to, its funder – typically government or local government. In this scenario, the organisation's very existence is underpinned by the goodwill and cash of the third party.

Staff, and other stakeholders in the organisation, must find a way of mediating between the political imperatives the arrangement generates, and the cultural integrity that makes the organisation interesting to the owner in the first place.

At the other extreme, a cultural organisation may enter into a delivery contract; an agreement to produce a set of outcomes or outputs in return for cash. A theatre group may deliver role-play training sessions for a corporate client, a museum may deliver memory workshops for care homes, a visual artist may create an installation for a corporate reception area.

In between these extremes, a large number of funders will give money to support the organisation being what it is, or changing what it is, or for doing something that it does, or for changing the way it does what it does. There are big, programmed, institutional funders (such as the Arts Council or the Lottery), and there are a variety of smaller, charitable foundations.

People Costs

For most culture organisations, staff are the single biggest cost. It is important to categorise those people costs by activity area, to that the contribution of that area can be determined. Typically, a culture organisation's main people headings would be based around the following headings:

- **Show**
 Including front of house, events, display, and production staff

- **Administration**
 Including senior management and finance staff
- **Assets and Infrastructure**
 Including buildings maintenance, security, curatorial, intellectual property teams
- **Commercial**
 Including retail, café, fundraising staff

Other Costs

Culture organisations will incur a range of other costs, depending on their business. These should be split into those that can be allocated to specific activity areas (e.g. the cost of buying products for the shop would normally be included in shop costs) and those that cannot. This latter set are, collectively, the overheads of the organisation. Some organisations will allocate some of those overhead costs to activities – they may, for instance, decide that, since 20% of the Director's time is spent on fund-raising, a similar proportion of her cost should be allocated to that activity or department. This would then result in a more accurate (and lower) contribution figure for the fund-raising department.

Such allocations are always a judgement: accountancy is much more imprecise than is commonly understood. But the key issue is this: that the total of the contributions made by each activity (e.g. show + shop + café + fundraising + grant) has to be more than the overhead cost, if the organisation is to remain in profit.

Ratios

Effective culture organisations know that they are unique. They also know that they are not – at least from a financial perspective – all that unique. They need to know the basic structure of their financial model and to know how key measures of that model compare to others in the sector. They will, in short, be interested in benchmarking themselves.

Benchmarking is not an exercise in following the herd, or in competing to be top of the XYZ indicator list. It is simply a means by which the organisation's leaders can ask themselves searching improvement questions. It may be right that ABC organisation spends a greater proportion of its budget on salaries than other similar players do – perhaps because of its fundamental need for a specific and expensive expertise – but it is as well for its management team to know that this is the case.

Financially, benchmarking is best achieved through ratios. Ratios allow comparison between organisations of different sizes. A very small theatre would get little insight from comparing its salary bill to that of a commercially successful, very large theatre. But there may well be learning to be derived from calculating, for both organisations, what proportion of total costs goes on salaries, and seeing whether any differences in this ratio help suggest changes that it could make.

The following are a basic set of financial ratios that most culture organisations should find useful as a way of comparing themselves to other players or groups of players.

Income Ratios

Admission income per visitor
Visitor income per visitor
Retail income per visitor
Retail gross margin
Catering income per visitor
Catering gross margin
Surplus/(Deficit) as proportion of income

Expenditure Ratios

Payroll as proportion of expenditure
Exhibition/show delivery costs as proportion of expenditure
Marketing costs as proportion of expenditure

Return on Investment

Most UK culture organisations have some dependence on the public purse and have, therefore, a public service orientation. In addition, many will have cultural rather than financial progress as a central ethos. Such organisations, as a result, find a narrow emphasis on profit to be, at best, alien and, at worst, anathema.

This can be a problem when looking to increase the enterprise and resilience of a culture organisation. In any organisation, prioritisation decisions are being made — actively or passively — all the time. If such decisions do not accommodate a financial perspective, even if that is just one of the perspectives employed, then the organisation will get itself into financial difficulties.

What does it mean for a culture organisation to include a financial perspective in its decision-making? Put simply, it means including **return on investment** thinking in the deliberations alongside wider issues such as artistic integrity, audience impact, and originality. It means asking what financial benefit we will get back from the investment we make, and it means using the ratio between the two (i.e. how many pounds do we get back for every pound we spend) as a way of helping to choose between possible options.

Even where a culture organisation is prepared to think in this way, it can be difficult to do in practice. So much of the spend can only be imprecisely estimated, as it will be about staff members who are undertaking the project as just one part of what they do. Much of the income from the project may be unclear: how will we know, for instance, how much of the café's business during a certain period resulted from footfall generated by a particular show?

These are real concerns. In truth, much of the financial analysis will be guesswork. But it can be informed guesswork: managers should be able to make estimates for such figures based on previous experience (and if they cannot, should they be in the positions they hold?).

For any given project, the following **staff costs** should be estimated:

Staff days required by project;
Staff cost per day;
Overhead uplift on staff costs (%).

Taken together, these will generate a figure for staff costs plus uplift. This cost should then be spread over the timescale of the project, following the profile of the required staff days.

Additional project costs should also be estimated and profiled over time, typically under the following headings:

> Project establishment costs;
> Project running costs;
> Third party costs;
> Other costs.

Total project investment is the sum of the above – i.e. the sum of staff and additional project costs

The "return" generated by the project – its profit, in simple terms – depends on the nature of the project. A typical, show-related culture organisation project will make money by attracting new visitors and/or finding ways to help existing and new visitors spend more of their money.

The calculation of the additional income this will generate contains the following variables:

- Current visitors;
- Increase in visitors;
- Current visitor income per visitor;
- Visitor income per additional visitor;
- Increase in visitor income for existing visitors;
- Current retail income per visitor;
- Retail income per additional visitor;
- Increase in retail income for existing visitors;

- Current catering income per visitor;
- Catering income per additional visitor;
- Increase in catering income for existing visitors.

A simple formula then produces the following totals:

o Increase in visitor income;
o Increase in retail income;
o Increase in catering income.

These three together would be the project's **total return**. They can also be profiled across the timeline of the project. The basic calculation of return is the amount of financial benefit the investment produces divided by the financial resources that were invested. If an investment of £100 yields a financial benefit of £110, the return would be 10%, as per the calculation below:

$$\text{Return} \quad = \quad \frac{£110 - £100}{£100} \quad = \quad 10\%$$

Return on investment (RoI) is method of calculating the success of an investment in financial terms. It is useful to be able to measure the success of an investment, though it is always worth bearing in mind that investments may deliver other benefits than purely financial. RoI also provides an objective comparison (of the financial returns only) from different investments. Before undertaking an investment, RoI can be used as a method of assessing which investment yields the greatest financial benefit.

A return over a period of time is expressed as a **rate of return**. The usual time period is a year. If, in the example above, the return of £10 was achieved in two years, the Rate of Return would be 5%, as per the calculation below:

$$\text{Rate of Return} = \frac{10\%}{2} = 5\%$$

The Rate of Return may change over time. The financial benefit may take some time before it is realised, so at first the Return and Rate of Return may be negative. An investment of £100 that yields a financial benefit of £70 in year one and £150 in year two would have the following Rates of Return.

$$\text{Year 1 Rate of Return} = \frac{£70 - £100}{£100} = -30\%$$

$$\text{Year 2 Rate of Return} = \frac{£150 - £100}{£100} = 50\%$$

The cumulative Rate of Return over two years would be:

$$\text{Cumulative Rate of Return} = \frac{£150 + £70 - £100}{£100} = 120\%$$

A cumulative Rate of Return over a number of years is sometimes expressed as an annualised rate.

In order to measure RoI, it will be necessary to identify the financial benefit of the investment and the financial resources invested. This is not always straightforward and may require some estimates and assumptions. Estimates and assumptions are often difficult, but this is not a science with a single right answer. RoI is used to support management judgement: it cannot provide risk-free "proof" of the correct approach.

The financial benefit would usually comprise an increase in income or a reduction in costs. The financial resources invested would usually comprise costs directly attributable to the investment, staff costs, and associated overheads. It is important to identify all the costs incurred, otherwise the Rate of Return will be overstated.

Simple Case Study

Imagine a scenario in which a theatre wants to improve its retail profitability. The two possible investments are improving the signage in the shop or undertaking customer service training with staff. The available budget is £5,000. The assumptions for the improved signage are that it would improve sales per month by 10%, from £10,000 to £11,000. The improved signage would cost £5,000. This would give a Rate of Return of:

$$\text{Rate of Return} \quad = \quad \frac{12 \times £1,000 - £5,000}{£5,000} \quad = \quad 140\%$$

The assumptions for the customer service training are that it would improve sales by 5% per month, from £10,000 to £10,500. The training would cost £3,000. This would give a Rate of Return of:

$$\text{Rate of Return} \quad = \quad \frac{12 \times £500 - £3,000}{£3,000} \quad = \quad 100\%$$

The improved signage shows a higher Rate of Return. However, there may be other non-financial benefits of the staff training proposal.

Note that, in practice, the potential rewards could not be as clearly determined in this example. Nonetheless, the case study illustrates how competing options – and claims concerning the benefits of those options – can be evaluated. A sensible manager would also include a risk factor against any claimed option.

CONCLUSION

There are some extraordinary and brilliant people in the culture sector. It is clear that culture can improve lives and lift economies. Is there any nobler pursuit than that? The problem is that the nobility of the endeavour can distract the players from attending to the basics of survival. Culture sector leaders need to recognise that, to continue their work, they also need to be enterprising and business-like.

Finally, here are 10 key truths for culture organisations seeking to make progress.

1. The artistic/commercial tension is the driver of success, not an unfortunate irritant.
2. Politics is intrinsic to your work. Political objectives need to be expressed, addressed, and balanced against financial and operational issues.
3. You cannot be all things to all people. The organisation needs to have a clear and compelling proposition.
4. You need to know who your core audiences are, and what they want.
5. A customer visit is simply a single episode in that individual's long-term relationship with your organisation.
6. The listening habit is simple, hard, and essential. The best ideas don't come from the top.
7. Unless people feel uncomfortable with the current state of play, they won't change.

8. Good management information underpins all other aspects of cultural enterprise. You need to understand which activities give you the best financial returns.
9. Operational consistency is underpinned by identifying and embedding a small number of simple core processes.
10. An effective enterprise culture happens when people feel safe to take risk.